ABC GAUDÍ

GEMMA PARÍS / MAR MORÓN

GG Los cuentos de la cometa

This book was made possible thanks to:

the original and creative works of Antoni Gaudí,
the generosity and the expert eyes of Jaume Sanmartí,
director of the Càtedra Gaudí,
the Fundació Catalunya-La Pedrera,
the Bellesguard House Estate,
the Diputació de Barcelona-Palau Güell,
the Museu Nacional d'Art de Catalunya,
the Consorci de la Colònia Güell,
the Junta Constructora del Temple de la Sagrada Família,
Joan, who let us in on some of the secrets of the Sagrada Familia,

and, above all,
the team at Editorial Gustavo Gili and Mònica Gili in particular,
for her keen interest and understanding.

For

Guillem, who accompanied me in my search for the treasures
hidden in Gaudí's buildings,
Eric and Teo, who are not surprised to see buildings adorned with
dragons and other fantastic creatures,
Marc, king of the Washingtonias,
My mother, and her collection of books on Gaudí,
Núria, for her keen eye, available at any time...

For

Begoña and Carlos, Juan Carlos and David,
Teresa, my family and friends...
...with whom I've shared so many good times.

Texts and graphic concept: Mar Morón and Gemma París
Foreword by Jaume Sanmartí i Verdaguer
Translation by Lola García Abarca

Photography by the authors except:
pp. 3, 31, 37, 43: © Càtedra Gaudí
pp. 15, 27: © Diputació de Barcelona-Palau Güell
p. 35: © shooarts
p. 49: © Steve Allen/Diputació de Barcelona-Palau Güell
p. 59: © Consorci de la Colònia Güell, 2015

Printed in Spain
ISBN: 978-84-252-2853-7

Editorial Gustavo Gili, SL
Via Laietana 47, 2°, 08003 Barcelona, Spain.
Tel. (+34) 93 322 81 61

Any 1900

Foreword

In his celebrated treatise entitled *De architectura* written two thousand years ago, Vitruvius postulated a series of necessary conditions in architecture. The field has undergone a myriad of changes since then, but his *utilitas, venustas, firmitas* has since become an essential part of its corpus. Read and interpreted in a variety of ways by many interested parties throughout history, these three essential qualities serve as a guide when looking at the structures produced within the fascinating and exciting field of architecture.

Antoni Gaudí was an exceptional architect, widely misunderstood during his lifetime, criticized by his peers and proponents of *Noucentisme* in particular, and promptly and unfairly forgotten after his death almost a century ago. For many years, his work was unjustly ignored, while in recent years it has been exalted by the media.

Gaudí lived and designed his singular architectural masterpieces at the beginning of the twentieth century during the peak of a very active European artistic movement that went by different names: *Art Nouveau*, *Secession style*, *the Arts & Crafts movement*, and others. In Catalonia, this movement was known as *Modernisme*, which enjoyed widespread support within the cultural realm of the Catalan *Renaixença*.

However, Gaudí was a genius, and geniuses are often difficult to categorize. Generally speaking, his work did not fully participate in the fashions of the day, and therefore to call his architectural style *Modernista* would be selling his works short. If, for the time being, we set aside the Sagrada Familia (a project that was not originally his and which, on numerous occasions, Gaudí asserted would be completed by someone other than him), we can see that his entire architectural repertoire, starting with his Vicens House and ending with his Milá House, is of great variety and originality. These buildings chart the evolution of his style and show how his work is consistent with his personal outlook on life.

If we return to the Vitruvian Triad, one can easily see that the function of a building, its *utilitas*, was central to Gaudí. As the quintessential man of the Tarragona hinterland, the architect always put a high value on functionality and common sense that comes with a job well done – a philosophy he learned as a child in his father's coppersmith's shop.

The way a building is constructed, its *firmitas*, is the result of a well-learned trade deeply rooted in the rich building tradition of Catalonia and an interest in the economy of means, that is, obtaining the most from the least. These ideas came from his masters Martorell, Fontserè and many other artisans that were heirs to the rich tradition of arts and crafts which Gaudí used to create new architectural forms of surprising beauty.

And finally, we have beauty, or *venustas*, the mystery that surrounds all creative acts. It is the result of a series of tasks seemingly unfettered by rules, which evoke certain emotions in the spectator when they look at the façade of a building and stroll through its inner spaces modulated by light. It is the "apparently inexplicable" phenomenon that transforms a noble structure into an architectural work.

History has shown that a good building is the result of the natural synthesis of these three categories. The singular case of Antoni Gaudí i Cornet is not an exception in this regard and fortunately for us, we can enjoy the architectural works of this unique and universally renowned architect up close and from front row centre.

Jaume Sanmartí i Verdaguer
Director of the Càtedra Gaudí — ETSAB-UPC

Dragons, palms, crosses and lizards

Take a stroll through any of the buildings designed by Antoni Gaudí and you will quickly be transported into a fairy tale world. Dragons and other mythological creatures adorn facades and rooftops; insects, crosses and mushroom-like forms serve as columns and arches; chimneys are warriors and trees, and windows are curved, colourful affairs; birds and eagles peer out at us from the alcoves above; undulating balconies sport railings that remind us of seaweed; we are surrounded by sinuous walls and ceilings that evoke the cottage in the tale of Hansel and Gretel; handrails wind around staircases as would the vertebrae of a marine animal; serpentine benches feature colours and forms taken from nature. Everything is possible in Gaudí's world. To gaze at his architectural works is to be surprised in a million ways.

Gaudí was a bold artist who was open to the stimuli of life, and especially the sensations evoked by nature itself. He imbibed everything that nature had to offer, ranging from the tiniest of perceptions to the spiritual, imbuing his work with all of these emotions. Gaudí was an original; he incorporated the novel into his work without losing sight of his roots and artisanal traditions. His work combined elements that represented more than the strictly architectural — including design and sculpture, for example — proof positive of his status as a multifaceted artist.

We have all dreamt about living in a fairytale house, or that buildings could be painted in different, more vibrant colours; many of us have longed to live in homes with larger, more organic spaces or have wanted to bring nature indoors. It was Gaudí who made this possible. When we look at his buildings we are astonished, surprised and drawn in by the great imagination which gave rise to new forms and spaces, his way with colour and his extraordinary building techniques. He made the impossible possible, and in so doing, he has made our dreams come true. His larger-than-life imagination appeals to young and old alike, to both Barcelonians and visitors from France and Japan. And not only because his buildings are beautiful living spaces, but also because they are places to dream in, where magic and pure creativity reign.

ABC Gaudí is our attempt to offer more than the traditional children's alphabet book, much the same way that Gaudí went beyond the limits of architecture with his work. Our aim is for children to learn to read and to also travel into a world of creativity, offering them a glimpse of the many possibilities in terms of representation, materials, form, colour and texture, helping them to slow down their gaze, enter Gaudí's fantastic world and fill their imaginaries with unlimited possibilities in terms of representation and creation.

Learning how to write, read and create with *ABC Gaudí* will encourage children to continue giving shape to their dreams, in a way that is creative, unique and personal.

Gemma París and Mar Morón

ARCHES

arches

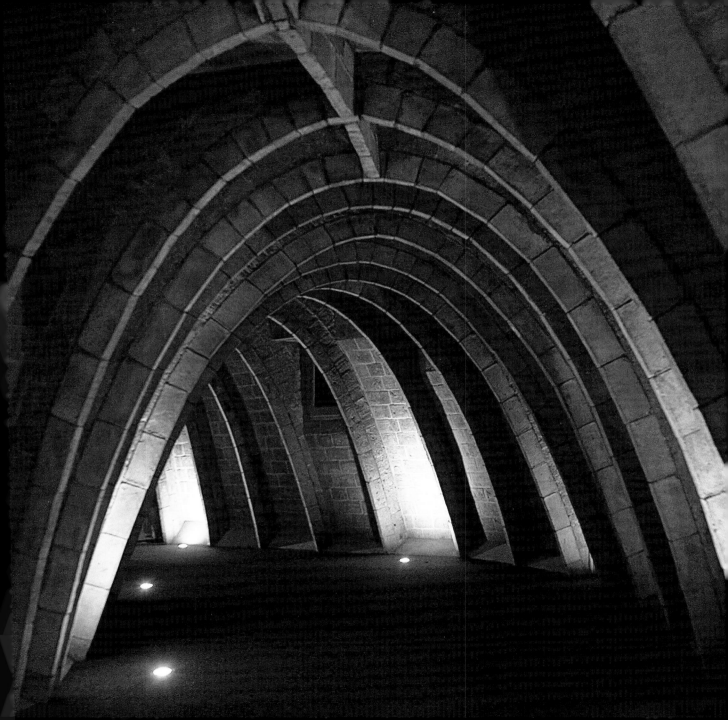

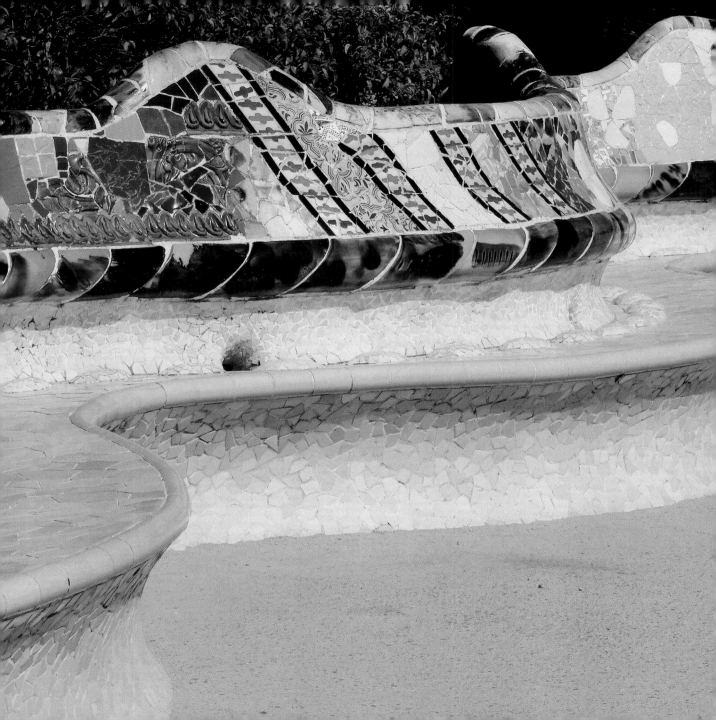

CROSS

cross

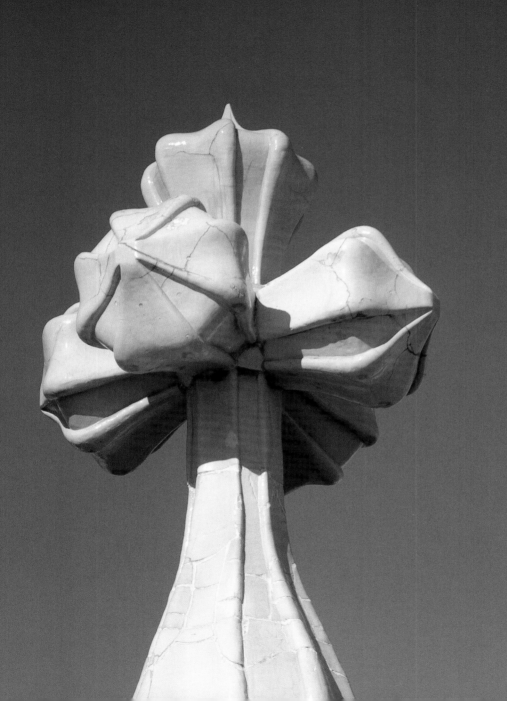

DOLPHIN

dolphin

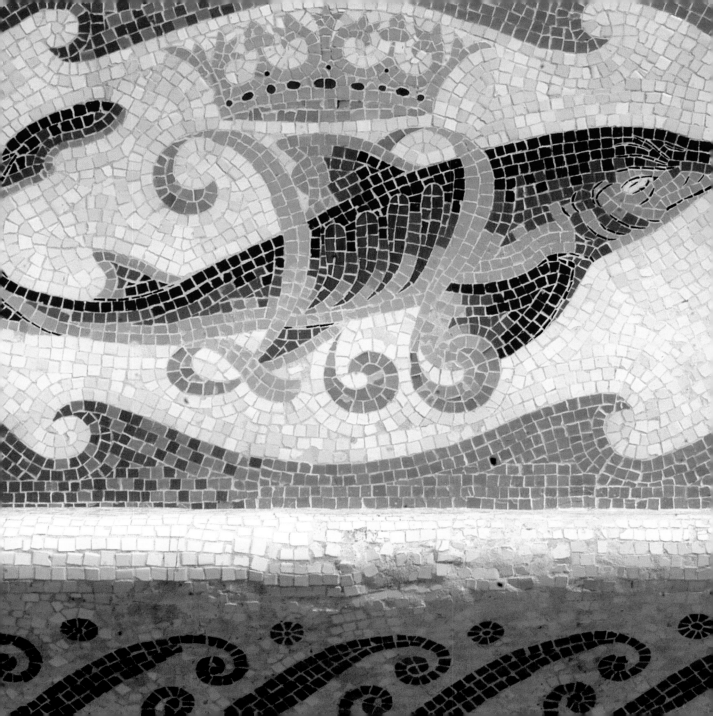

EAGLE

eagle

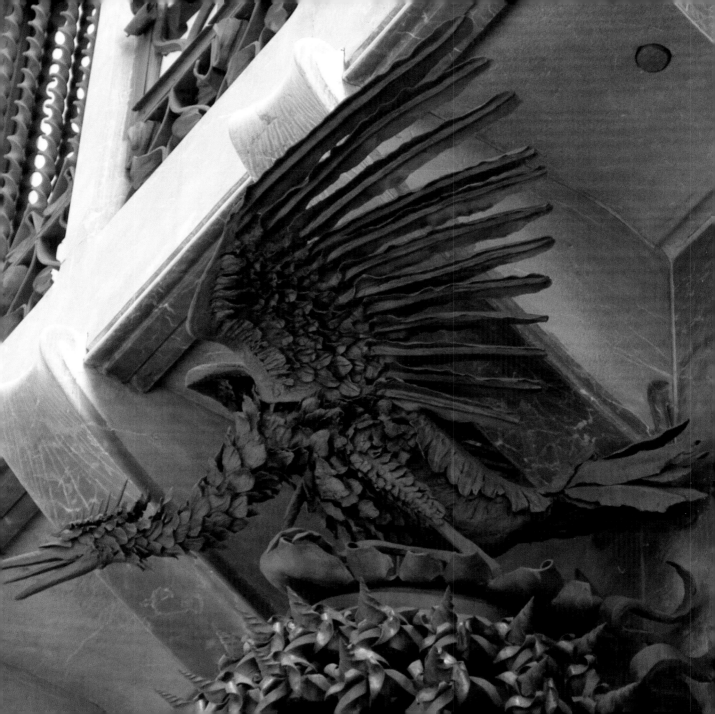

FLOWERS

flowers

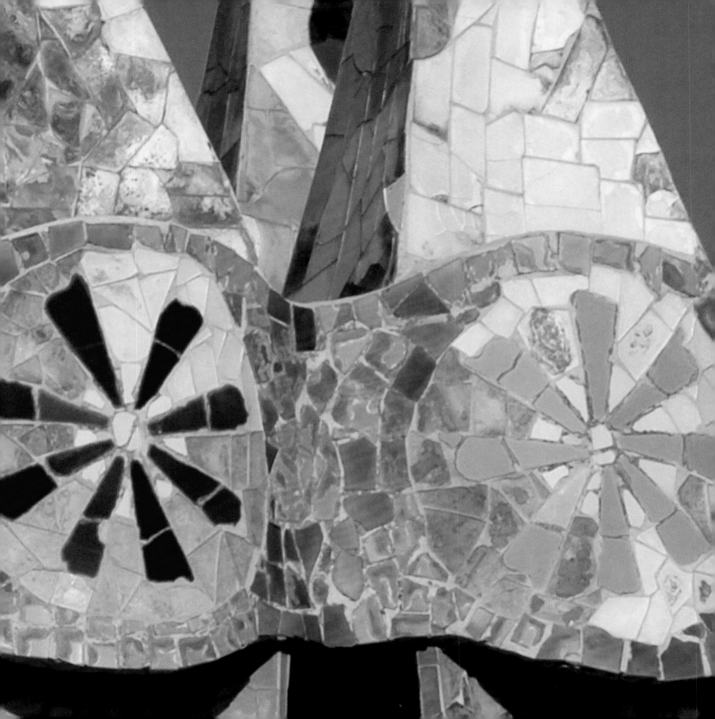

GRILLE

grille

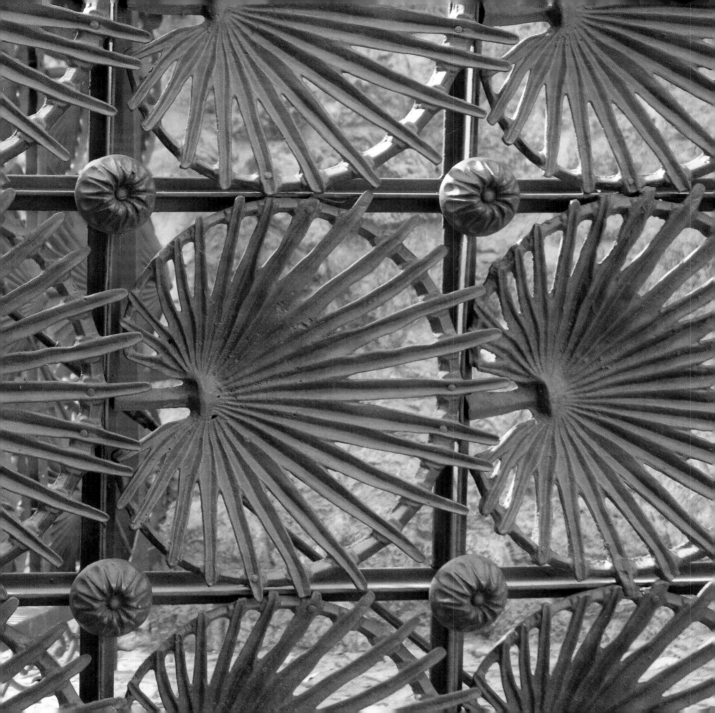

HOUSE

house

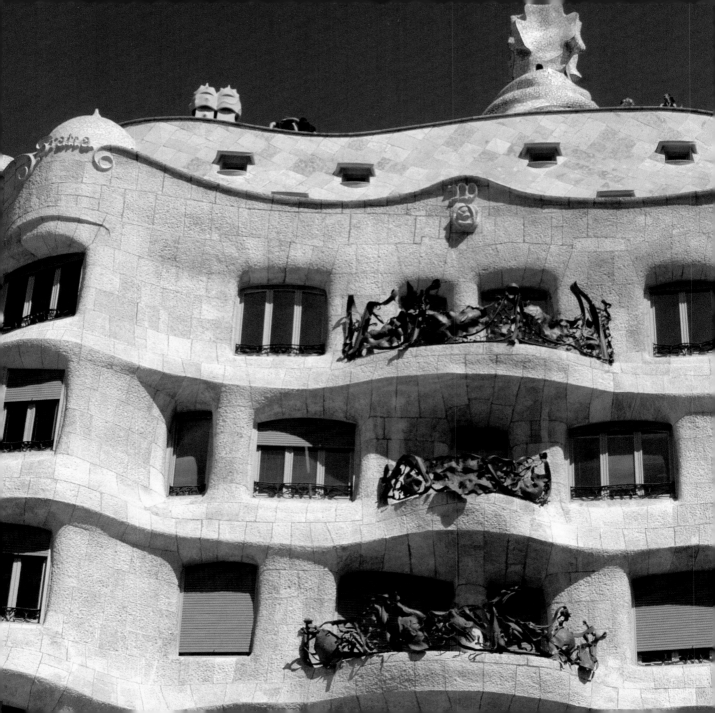

INSECT

insect

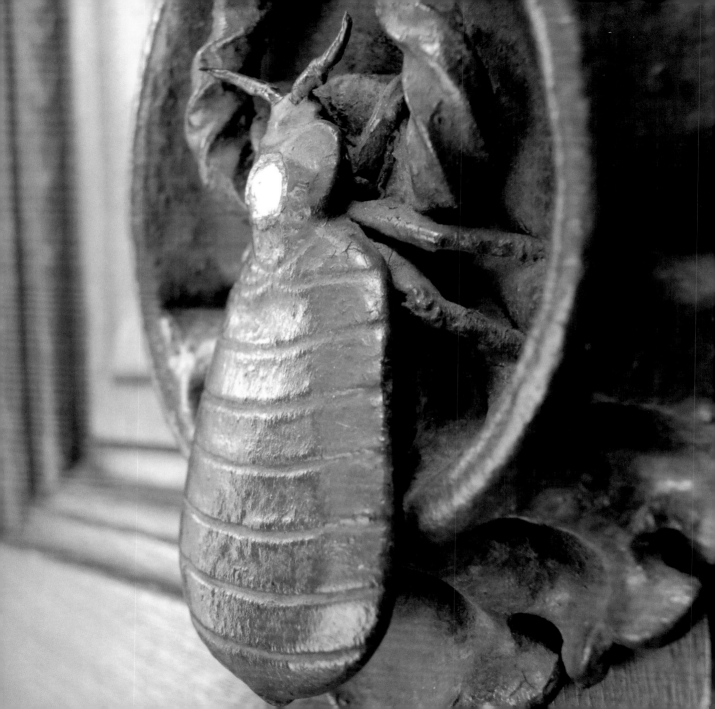

JAW

jaw

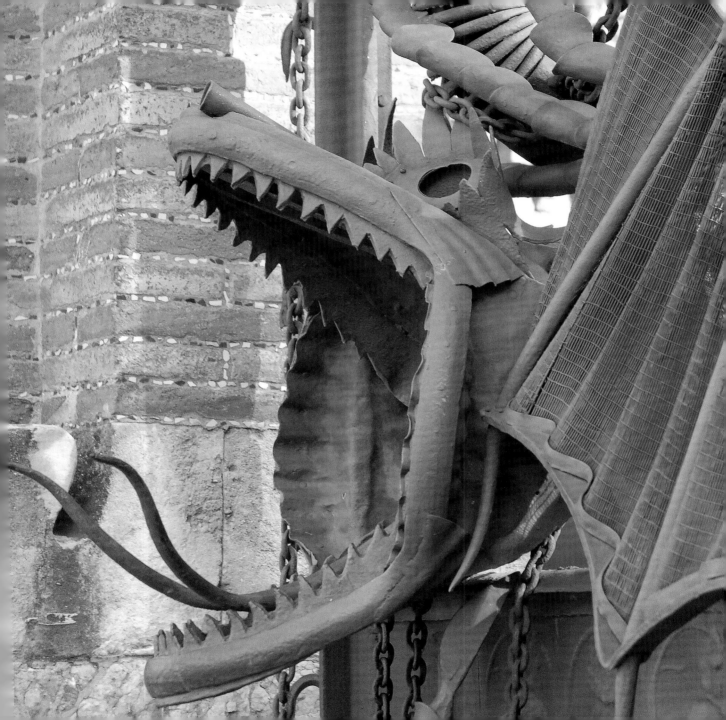

K

BRICKS

bricks

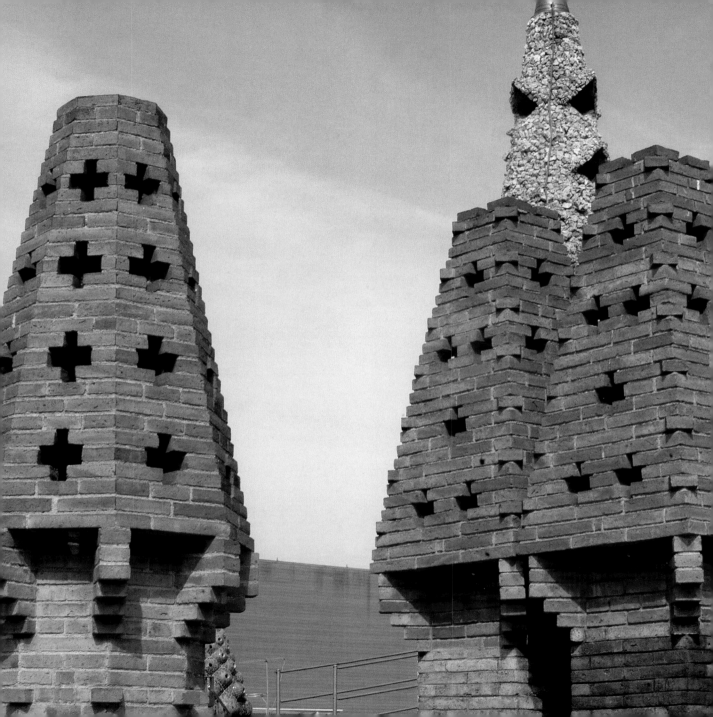

LIZARD

lizard

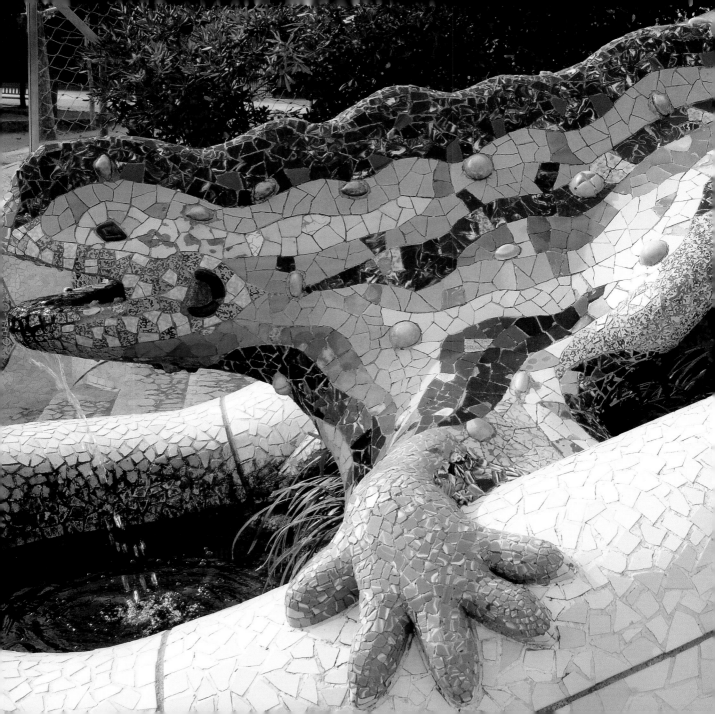

MODEL

model

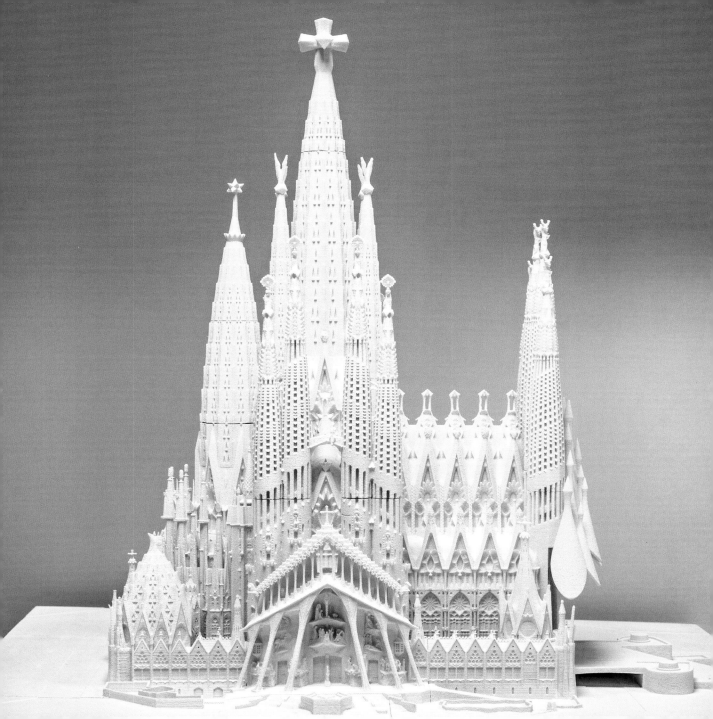

NUMBER

number

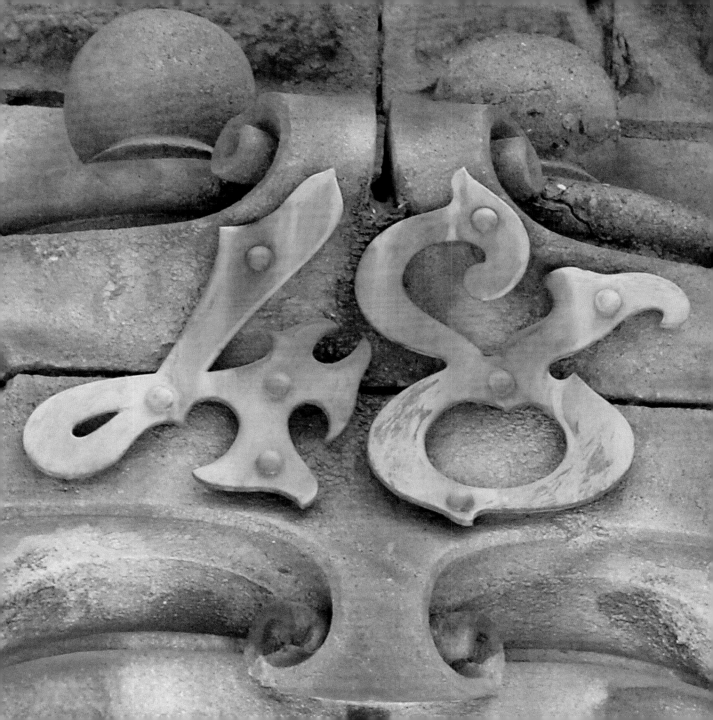

OCTOPUS

octopus

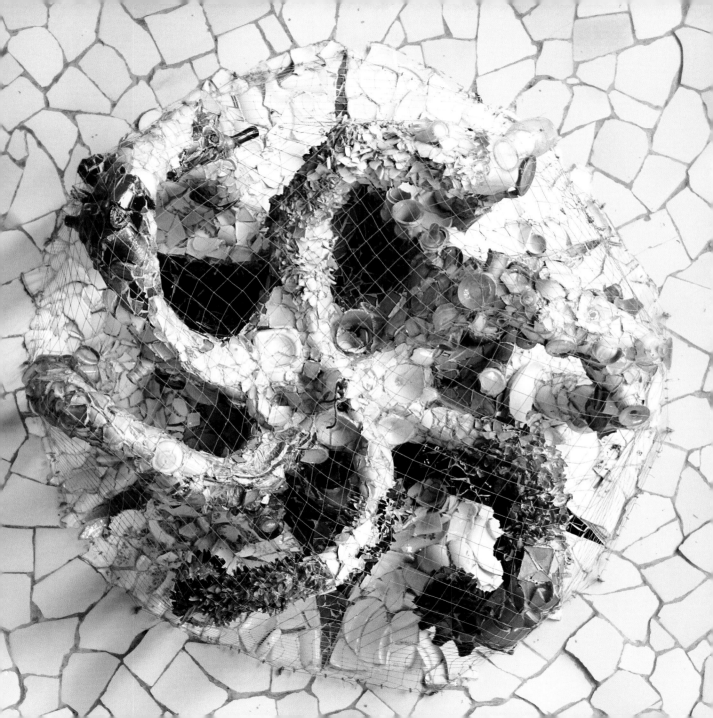

PLAN

plan

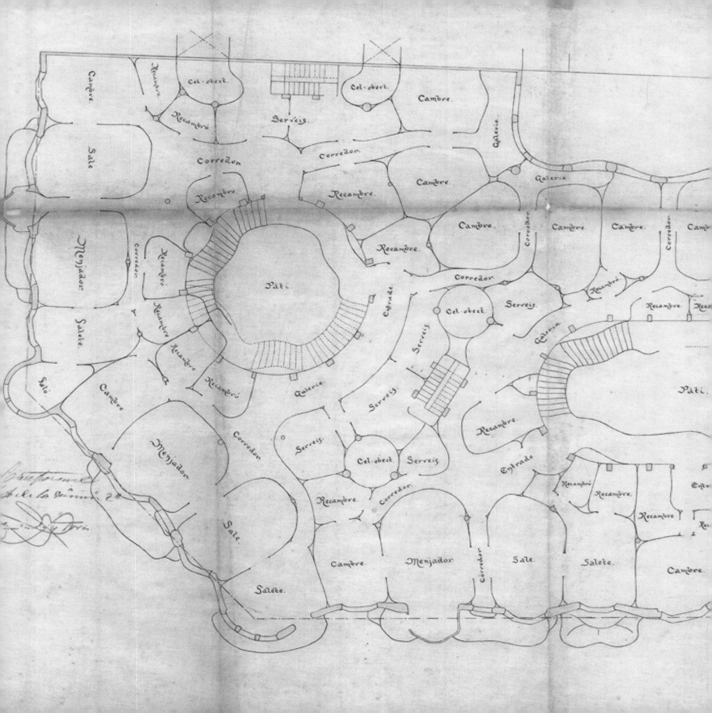

SQUARE

square

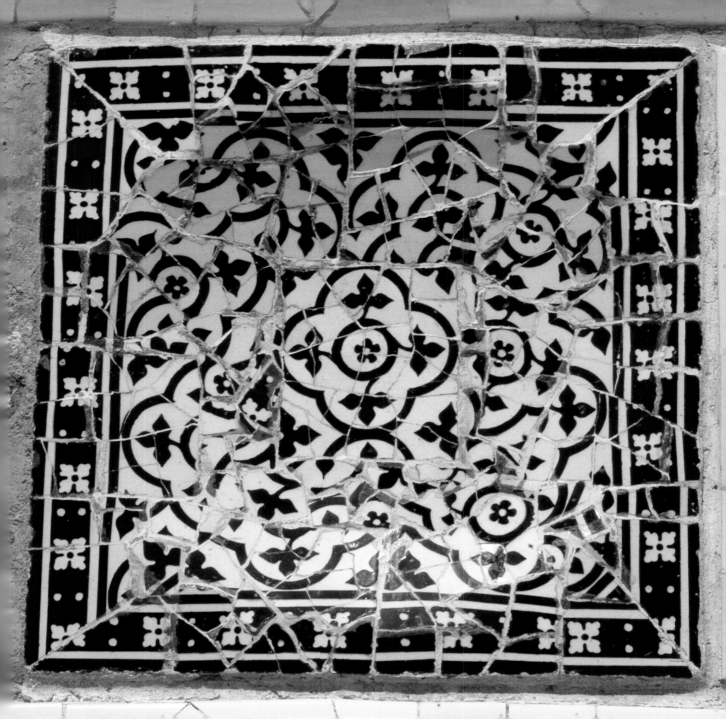

ROOF

roof

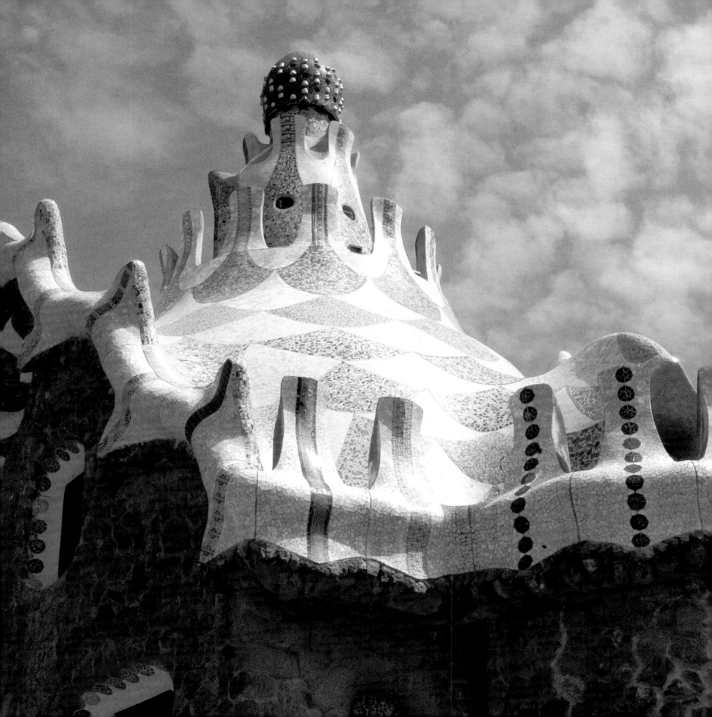

SKETCH

sketch

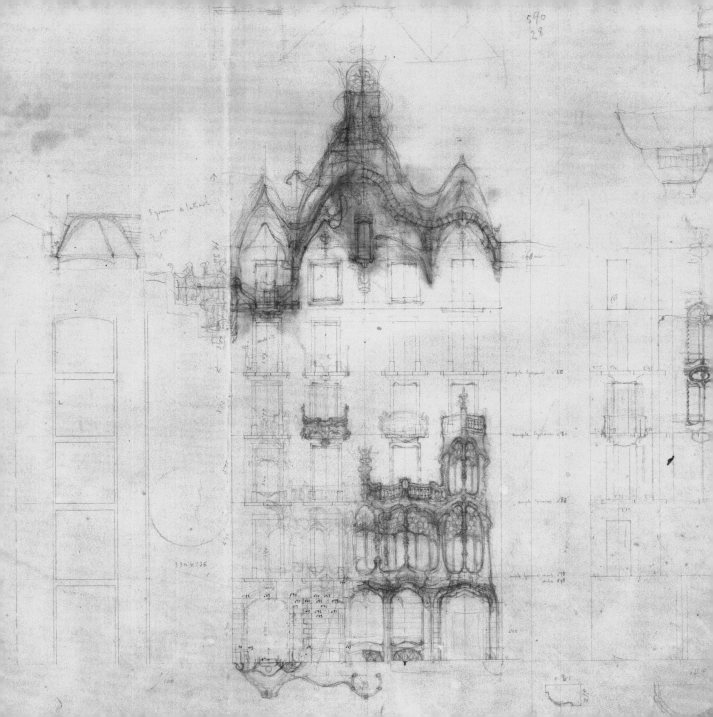

TRENCADÍS

trencadís

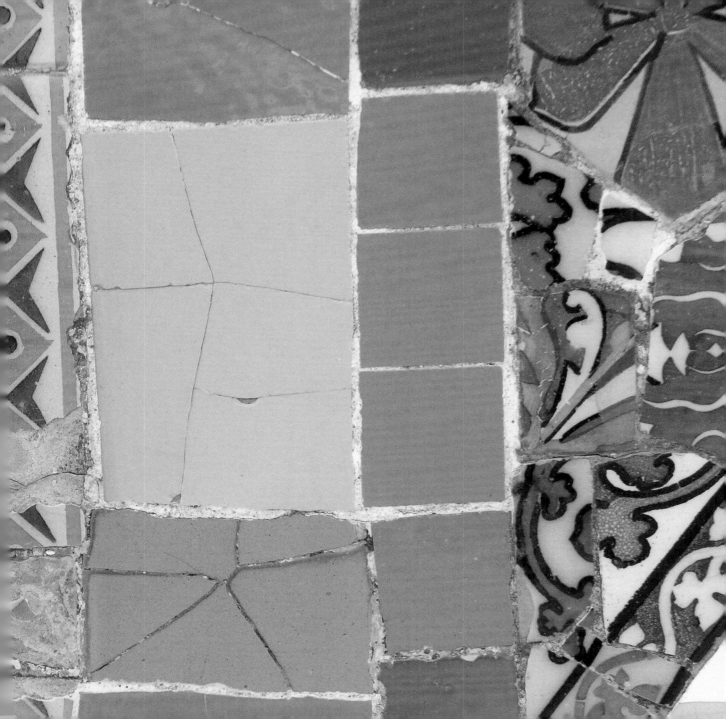

BLUE

blue

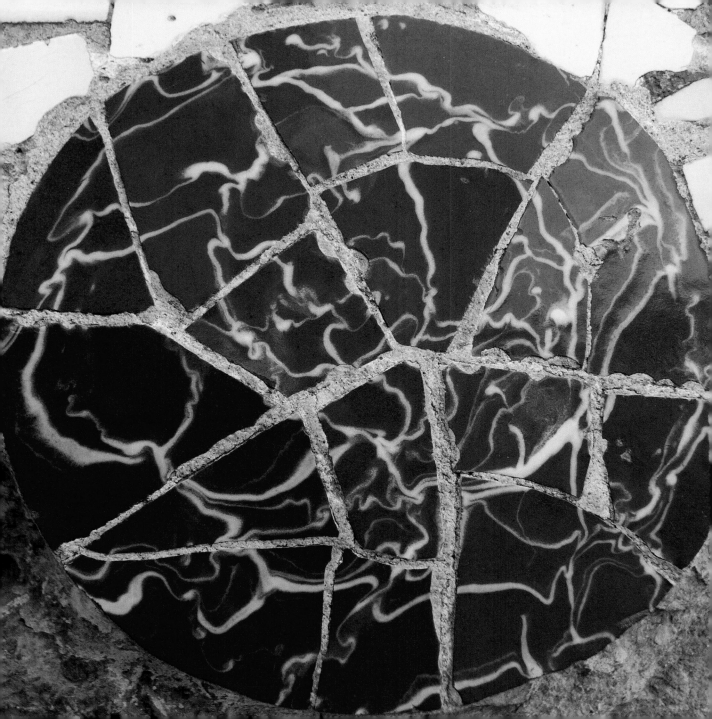

VANE

vane

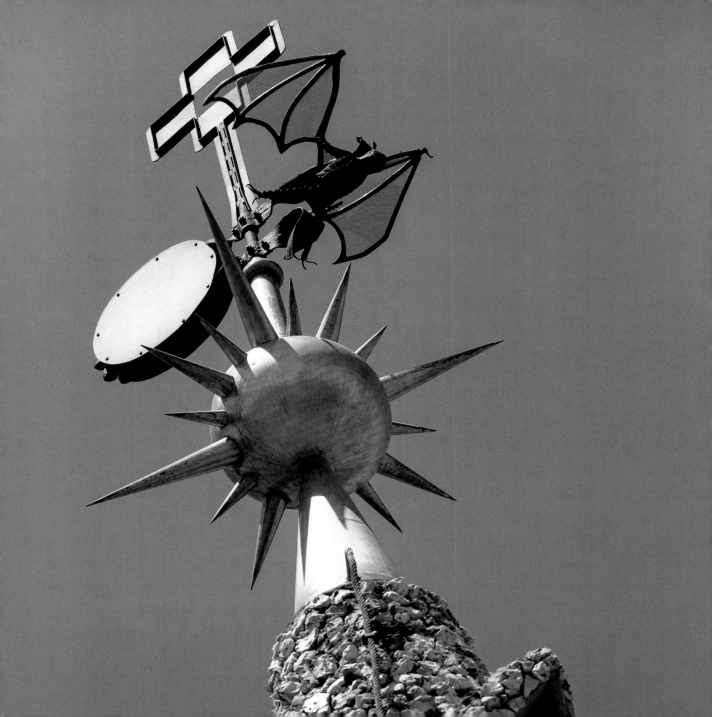

WINDOW

window

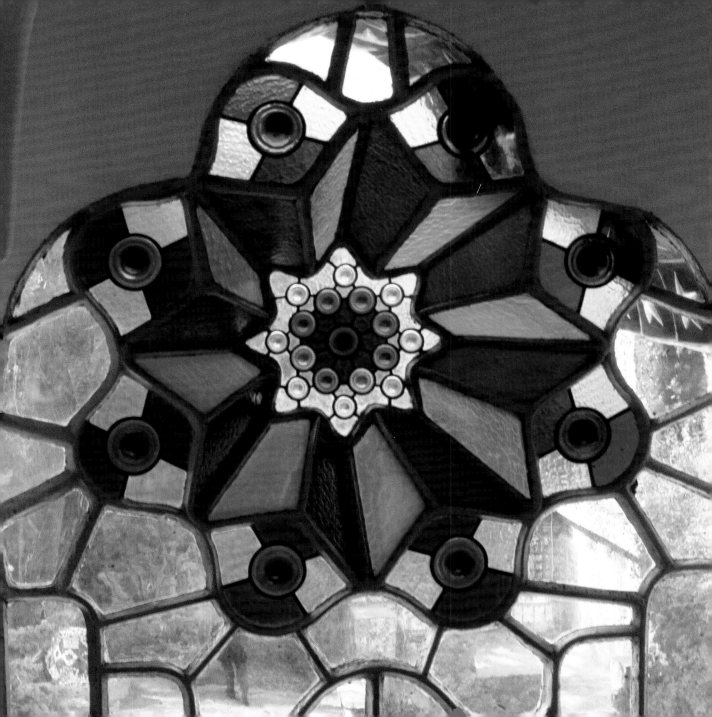

HEXAGON

hexagon

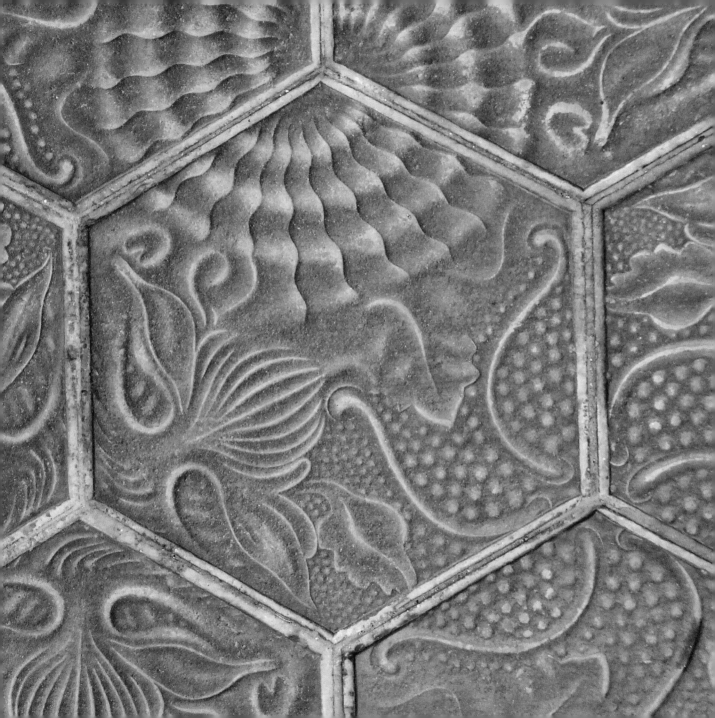

CHIMNEYS

chimneys

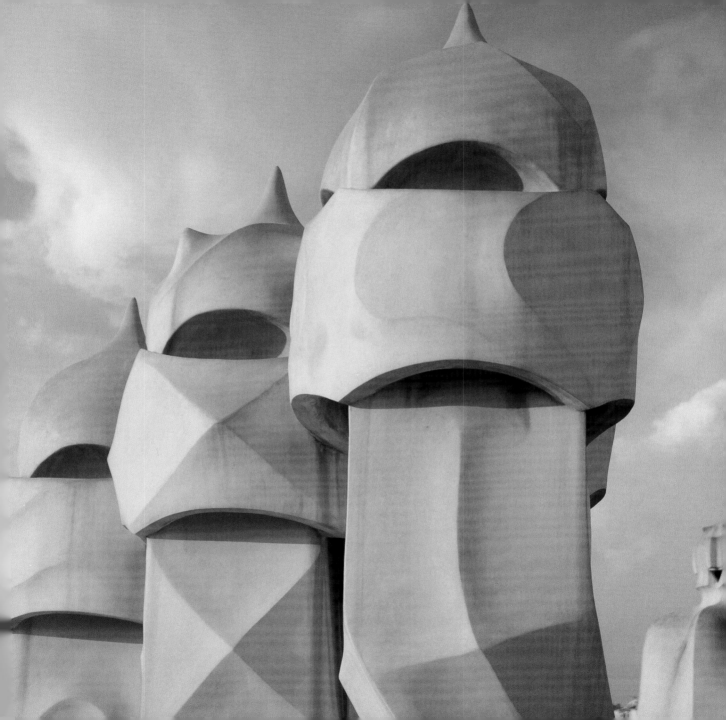

ZIGZAG

zigzag

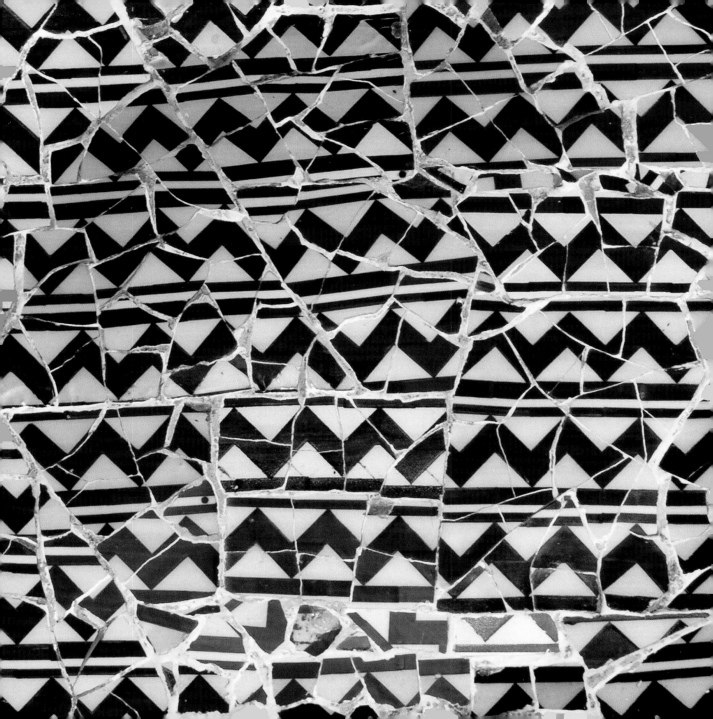

GÜELL PALACE

Carrer Nou de la Rambla, 3-5
Barcelona
Built between 1886 and 1890

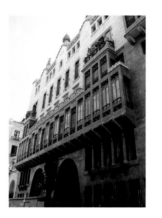

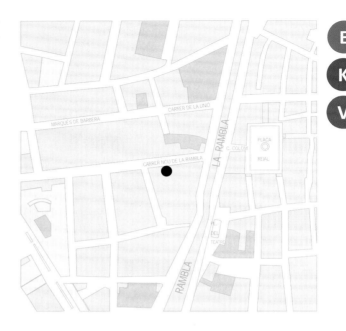

CALVET HOUSE

Carrer Casp, 48
Barcelona
Built between 1898 and 1900

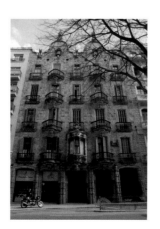

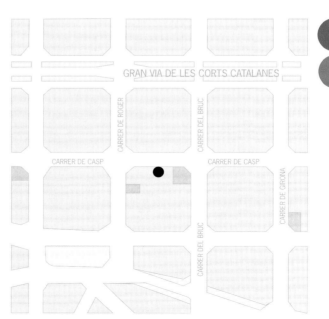

BELLESGUARD HOUSE

Carrer Bellesguard, 16-20
Barcelona
Built between 1900 and 1909

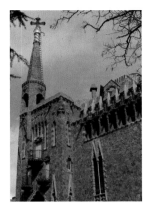

CRYPT FOR COLÒNIA GÜELL

Carrer Claudi Güell, s/n
Santa Coloma de Cervelló
Colònia Güell
Built between 1908 and 1914

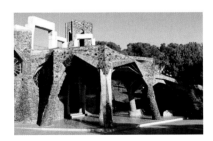

BATLLÓ HOUSE

Passeig de Gràcia, 43
Barcelona
Complete renovation of
existing building, 1904-1906

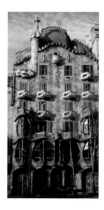

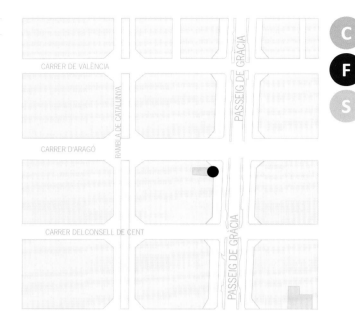

MILÀ HOUSE - LA PEDRERA

Passeig de Gràcia, 92
Barcelona
Built between 1906 and 1910

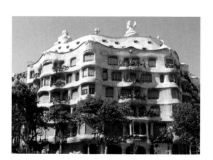

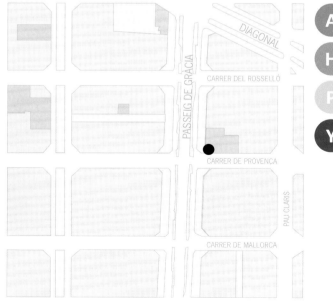

PARK GÜELL

Carrer d'Olot, s/n
Barcelona
Built between 1900 and 1914

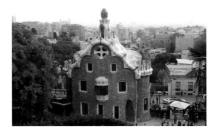

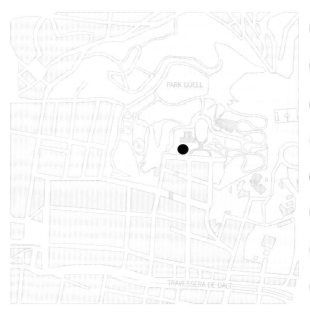

PAVILIONS AT GÜELL ESTATE

Avinguda Pedralbes, 15
Barcelona
Built in 1887

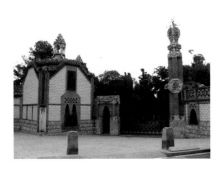

SAGRADA FAMÍLIA

Carrer Mallorca, 402
Barcelona
Construction began in 1882

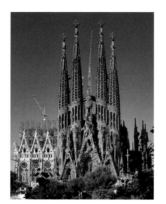

VICENS HOUSE

Carrer de les Carolines, 24
Barcelona
Built between 1883 and 1888

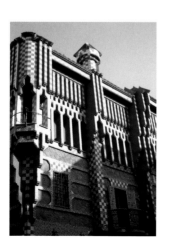

Gemma París Romia Artist and professor of Art Education at the Faculty of Education of UAB Barcelona; PhD in Fine Art from the University of Barcelona. She has been awarded numerous visiting artist grants for stays in Mexico City, London, Paris and Argentina which have allowed her to carry out her artistic work in new settings, in addition to showing her work in numerous institutions and galleries in cities such as Barcelona, Paris, Madrid, Lleida and Milan. gemma.paris@uab.cat

Mar Morón Velasco Professor of Art Education at the Faculty of Education of UAB Barcelona; Artist, PhD in art education and creator of artistic projects for schools and museums for persons requiring special needs. Lines of research: Education through art, art education, and special education. Author of website: *L'art del segle xx a l'escola*. mar.moron@uab.cat

7